# YORK

## HISTORY TOUR

First published 2018

Amberley Publishing
The Hill, Stroud,
Gloucestershire, GL5 4EP
www.amberley-books.com

Copyright © Paul Chrystal, 2018
Map contains Ordnance Survey data
© Crown copyright and database
right [2018]

The right of Paul Chrystal to be
identified as the Author of this work
has been asserted in accordance with
the Copyrights, Designs and Patents
Act 1988.

ISBN  978 1 4456 8165 8 (print)
ISBN  978 1 4456 8166 5 (ebook)

British Library Cataloguing in
Publication Data.
A catalogue record for this book is
available from the British Library.

Originating by Amberley Publishing.
Printed in Great Britain.

# INTRODUCTION

As befits one of Europe's most beautiful and historical cities, many books have been written praising York's heritage and magnificence. So, why another? *York History Tour* is different from all the rest in a number of ways. It is practical, fitting as it does into your bag or pocket, and has maps to guide you effortlessly around the city's many treasures. It also contains pictures from three unique sources: the stunning photographic archive of the Yorkshire Architectural and York Archaeological Society, the photographic archive of *York Press*, and my own photographic collection.

If you want a guide to the city of York that takes in all that is best to see, then take this book with you to discover more about this wonderful city.

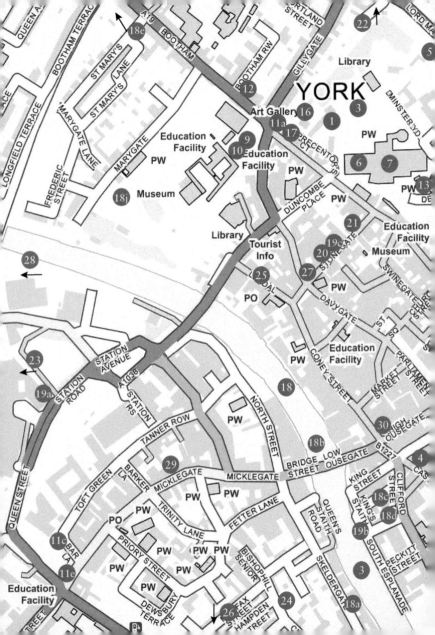

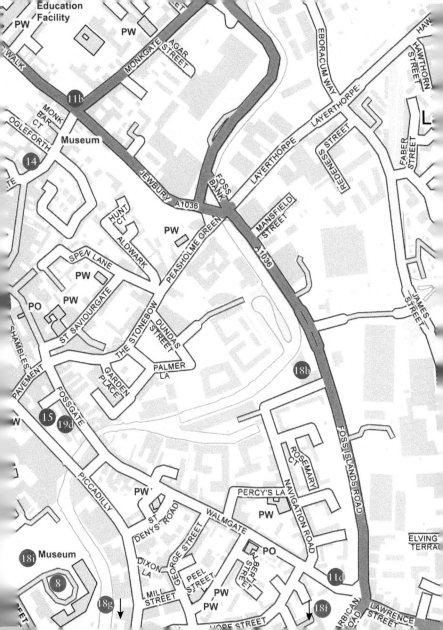

# KEY

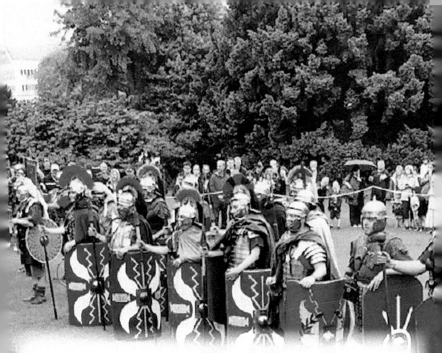

# 1. ROMAN YORK (EBORACUM)

York is essentially a Roman city, despite the ubiquity of Viking history. Eboracum was occupied by the Romans from AD 71 until AD 410, when they left Britannia for good. Quintus Petillius Cerialis led the IX Hispana Legion north to subdue the Brigantes and established a garrison here. Strategically, York was of major significance, being of considerable military importance and a major communications centre. The Colonia covered 60 acres and the walls were 20 feet high and 4 feet thick in parts. The Praetorium is under the Minster, there is an amphitheatre and temple under Micklegate, a forum basilica, baths on the banks of the Ouse, a sewerage system in Bishophill, and a VI Victrix Legion column opposite the Minster. This photo was taken at the 2018 York Roman Festival. (Courtesy of Anne Chrystal)

# 2. CONSTANTINE STATUE

The statue of Constantine near the Minster was made to celebrate his being proclaimed emperor here in AD 306 after the death of his father here, the Emperor Constantius Chlorus, and his conversion to Christianity in York in around 312. Septimius Severus, Rome's first black emperor, lived in York between 208 and 211. His sons Caracalla and Geta were declared co-emperors in 198 and 209. Severus died in York in 211 and received a spectacular funeral in the city, but not before he had declared York to be the capital of Britannia Inferior. Hadrian visited too.

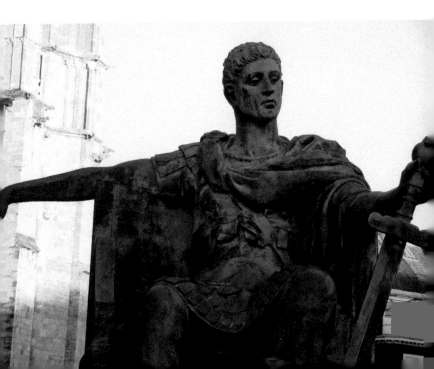

# 3. THE VIKINGS ARE COMING

Viking ships sailing down the Ouse at King's Staith (in 1985). The Viking army attacked the city on 1 November 866 under the command of Halfdan and Ivar the Boneless. The date was no coincidence, it being All Saints' Day when much of the population would have been preoccupied in the old cathedral. York soon became the capital of the Viking kingdom in the north. In 954 the last Viking king, Eric Bloodaxe, was expelled. Ivar was known as 'Boneless' on account of his chubby face. He was the son of Ragnar Lothbrok. (Courtesy of *York Press*)

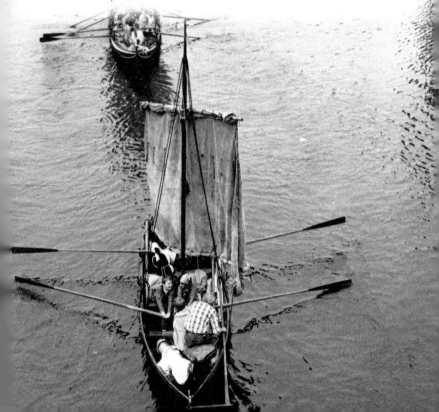

# 4. JORVIK VIKING CENTRE

The only significant archaeological finds in York before the 1970s were dug up by chance. But this all changed when an area below Lloyds Bank in Pavement was excavated by York Archaeological Trust before the redevelopment of Coppergate in 1976 – within days rare traces of Viking-age timber buildings were revealed. The dig covered 1,000 square metres and so between 1976 and 1981 archaeologists were able to excavate 2,000 years of York's history. In that time York Archaeological Trust identified and recorded around 40,000 items. The site revealed 5 tons of animal bones, mostly food leftovers consumed over the centuries; vast quantities of oyster shells (a cheap and popular food over the years); thousands of Roman and medieval roof tiles; building materials including wattle, timber and metal slag; 250,000 pieces of pottery; and 20,000 other individually interesting objects. Many of the Viking artefacts are on display here along with a vibrant reconstruction of Viking life. The image here shows one of the vivid reconstructions that has come out of the excavations. Meet Eymund in the Jorvik Viking exhibit. He was born around AD 948 and has been reconstructed from a male skeleton unearthed in a Viking cemetery in Fishergate. (Courtesy of *York Press*)

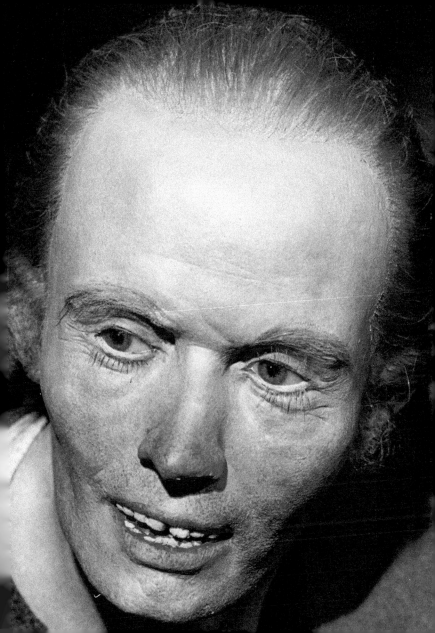

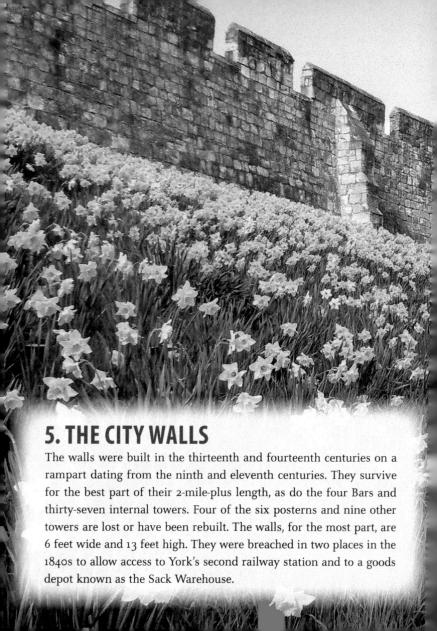

## 5. THE CITY WALLS

The walls were built in the thirteenth and fourteenth centuries on a rampart dating from the ninth and eleventh centuries. They survive for the best part of their 2-mile-plus length, as do the four Bars and thirty-seven internal towers. Four of the six posterns and nine other towers are lost or have been rebuilt. The walls, for the most part, are 6 feet wide and 13 feet high. They were breached in two places in the 1840s to allow access to York's second railway station and to a goods depot known as the Sack Warehouse.

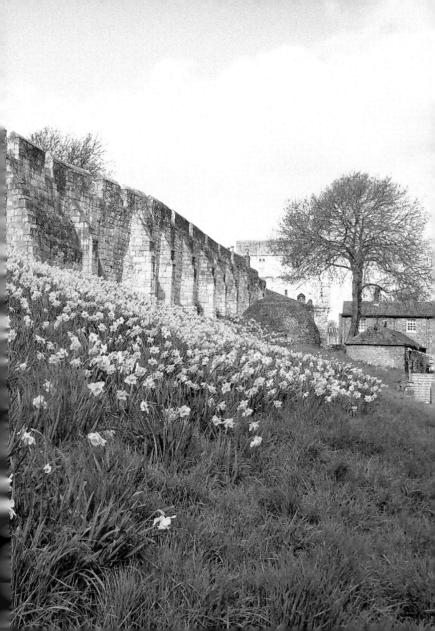

# 5A. THE CITY WALLS

Grass cutting on the walls. (Courtesy of *York Press*)

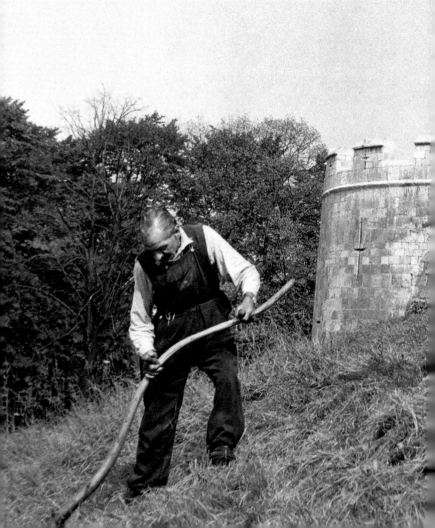

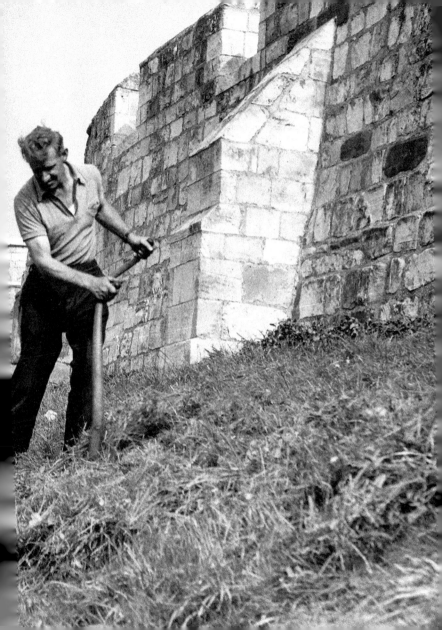

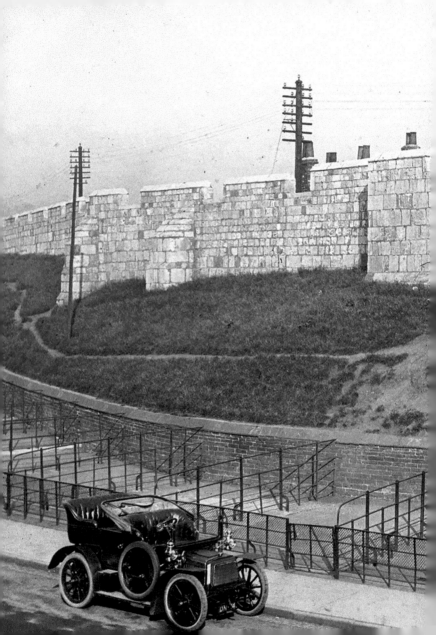

## 5B. THE CITY WALLS

The walls and the cattle market. Note the worn-down state of the embankment. (Courtesy of *York Press*)

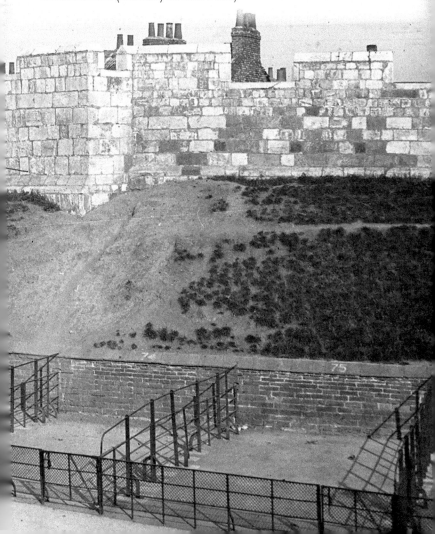

# 6. YORK MINSTER

The Minster's official name is the Cathedral and Metropolitical Church of St Peter in York. It is the largest medieval building in England and the biggest cathedral in Europe north of the Alps. It towers on the site of an earlier Norman cathedral, which was almost as huge and took 250 years to build from 1220 to 1470. The Minster's treasures are countless. They include 128 stained-glass windows from the twelfth to the twenty-first centuries, most notable of which is the 1408 Great East Window – the size of a tennis court and the world's largest area of stained glass. The Minster is built in the shape of a cross, facing east towards Jerusalem.

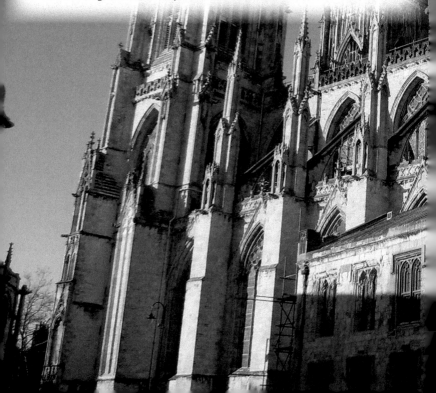

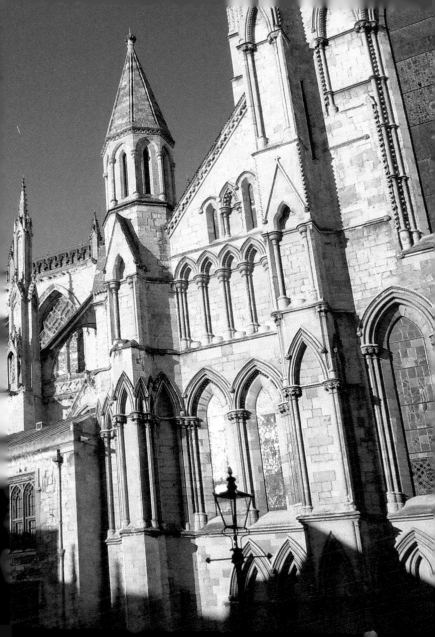

# 7. GREAT PETER

The 10.8-ton bell known as Great Peter arrived back at a York Minster in 1914 after restoration – ten horses were required to pull the cart. The bell was originally cast by John Taylor & Co. of Loughborough in 1840 and is Britain's second biggest bell after Great Paul, which hangs in St Paul's Cathedral – Taylor's cast this too. Great Peter is the heaviest of the Minster's ring of twelve bells, but despite its weight can be swung and rung by one person. It is the deepest-toned bell in Europe. Taylor's was established in 1784 and still trades today. The bells were restored and returned here in March 1914 by John Warner & Sons Ltd from their Spitalfields bell foundry. The Minster can boast thirty-five bells in total. The north-west tower contains Great Peter and six clock bells (the largest weighing 3 tons). The south-west tower houses fourteen bells, which are hung and rung for change ringing, and twenty-two carillon bells, which are played from a baton keyboard in the ringing chamber. (Courtesy of *York Press*)

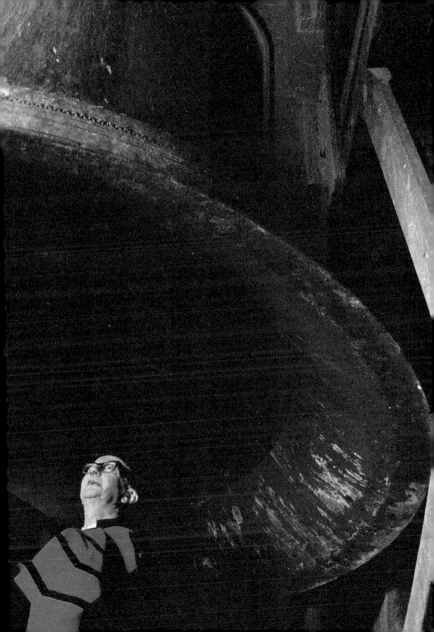

# 8. CLIFFORD'S TOWER

This was originally called King's Tower, or even the 'Minced Pie'; however, in 1596 it was named Clifford's Tower after Francis Clifford, Earl of Cumberland, who restored it for use as a garrison after it had been partly dismantled by Robert Redhead in 1592. An alternative reason for its name is that it comes from Roger de Clifford, whose body was hung there in chains in 1322. Built in wood by William the Conqueror when he visited to establish his northern HQ in 1190, it was burnt down when 150 terrified York Jews sought sanctuary here from an anti-Semitic mob. Faced with the choice of being killed or having a forced baptism, many committed suicide and 150 others were slaughtered. It was rebuilt in stone by King John and Henry III as a quadrilobate between 1245 and 1259 as a self-contained stronghold and royal residence. It housed the kingdom's treasury in the fourteenth century. Robert Aske, one of the prime movers in the Pilgrimage of Grace, was hanged here on 12 July 1537. On 23 April 1684 the roof was blown off during an overenthusiastic seven-gun salute. Deer grazed around the tower for many years and it became part of the prison in 1825.

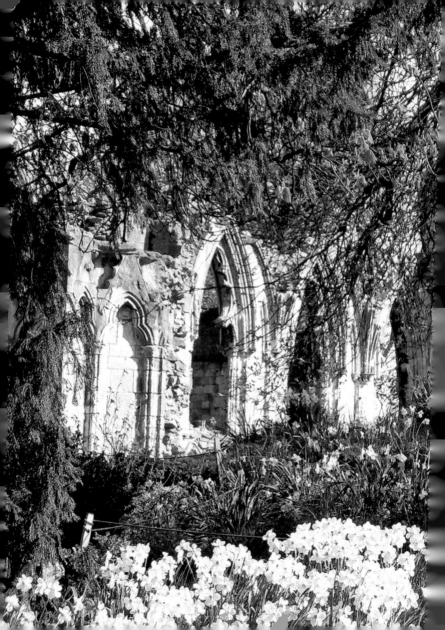

# 9. ST MARY'S ABBEY

One of the richest abbeys in the country, the Benedictines completed it in 1088 only to have Henry VIII ruin it. The surrounding walls (originally three-quarters of a mile long) were built after the townsfolk's attacks on the abbey when one of the clerics – Simon de Warwick – imposed taxes on the market along Bootham, outside the city walls. In 1132, Richard, the prior, and thirteen monks demanded a return to a traditionally simpler life, which also involved giving away much of the abbey's money. After a near riot, the rebels left York to found the much stricter Cistercian Fountains Abbey. The life-sized stone saints and prophets painted in gold and other colours that adorned the west front of St Mary's Abbey Church are now in the Yorkshire Museum. They included Moses adorned with horns, which was typical of the medieval period due to a mistranslation of the Hebrew Bible into the Latin Vulgate Bible. The Hebrew word taken from Exodus can mean either a 'horn' or an 'irradiation' and in this case should be the latter. The most famous horned Moses is Michelangelo's statue in the Church of San Pietro in Vincoli, Rome.

# 10. MUSEUM GARDENS

The abbey can be seen in ruins in the background with the hospitium to the left. (Courtesy of Yorkshire Architectural and York Archaeological Society)

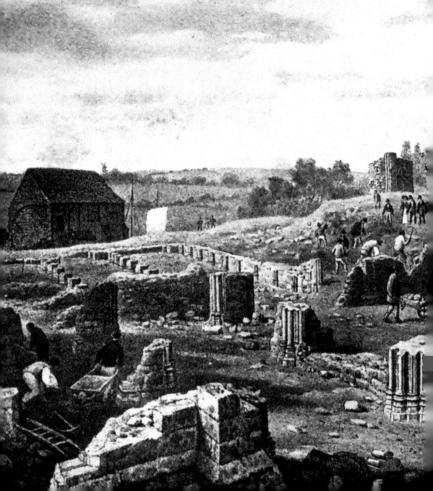

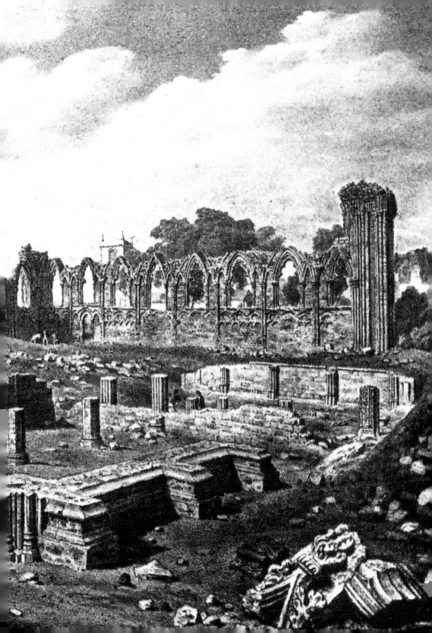

# 11. THE BARS

## 11A. BOOTHAM BAR

Bootham Bar stands on the north-western gateway of the Roman fortress and was originally called Galmanlith. The name 'Buthum' means 'at the booths', which is indicative of the markets that used to be held here. A door knocker was added to the Bar in 1501 for the use of Scotsmen (and others presumably) seeking admission to the city. The barbican came down in 1831 and the wall steps went up in 1889. A statue of Ebrauk, the pre-Roman founder of York, once stood nearby. Thomas Mowbray's severed head was stuck here in 1405 and the Earl of Manchester bombarded the Bar in 1644 during the Civil War. The removal of the barbican in 1831 was due, in part, to complaints by residents of Clifton, with some saying it was 'not fit for any female of respectability to pass through' on account of the animals' droppings found en route to the cattle market and its use as a urinal by pedestrians. The three statues on the top were carved in 1894 and feature a medieval mayor, a mason and a knight; the mason is holding a model of the restored Bar. (Courtesy of Yorkshire Architectural and York Archaeological Society)

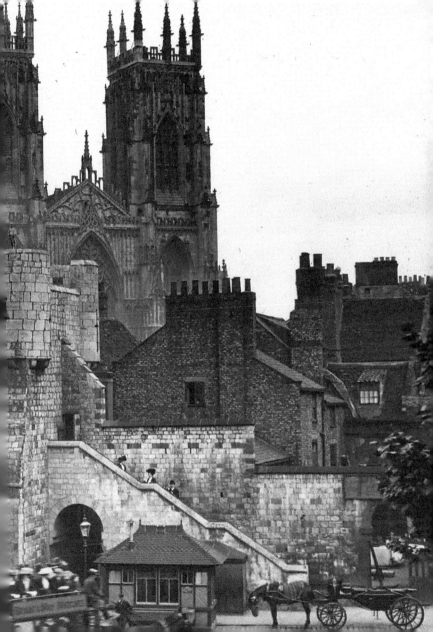

## 11B. MONK BAR

Built around 1330, Monk Bar was originally called Monkgate Bar and at 63 feet it is the tallest of York's Bars. Designed as a self-contained fortress, assailants had to cross each floor to reach the next flight of stairs, thus exposing themselves to defensive fire. A perfect fortress, the Bar features loopholes (for bows and arrows), gun ports and murder holes (from which heavy objects and boiling water might be dropped). The coat of arms is Plantagenet. The Bar was used as a prison in the sixteenth century for recusant Catholics and others too; for example, in 1588 Robert Walls was imprisoned for 'drawing blood in a fray'. The barbican was removed in the early 1800s. To rent the rooms at the top, one Thomas Pak (Master Mason at the Minster) paid 4s per annum. (Courtesy of Yorkshire Architectural and York Archaeological Society)

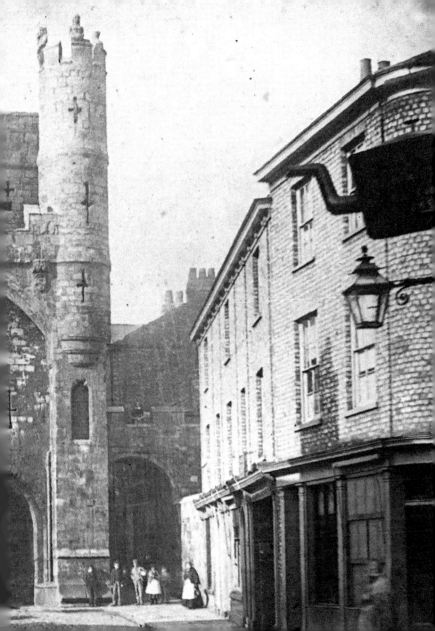

## 11C. MICKLEGATE BAR

Micklegate Bar was originally called Mickleith, which means 'great gate'. The royal arms are those of Edward III, the arch is Norman and the rest is from the fourteenth century, though the side arch was added in 1753. Being on the road to and from London, this was the Bar through which royal visitors entered York – Edward IV, Richard III, Henry VII, Margaret Tudor, James I, Charles I (on three occasions during the Civil War) and James II all passed through. Henry VIII was scheduled to enter here but in the event came in through Walmgate Bar. Heads and quarters of traitors were routinely displayed on the top, most famously Lord Scrope of Mastan in 1415; Sir Henry Percy (Hotspur) after his part in the rebellion against Elizabeth I; Richard

Duke of York after the Battle of Wakefield in 1460, prompting Shakespeare to write 'Off with his head and set it on York's gates; so York did overlook the town of York' (Queen Margaret in *Henry VI*); and Thomas Percy in 1569 – his head remained there for two years. Removal of heads without permission was, not inappropriately, punishable by beheading – guess where the heads ended up. The last displays were in 1746 after the Jacobite Rebellion at Culloden. The heads of James Mayne and William Connelly remained on the Bar until 1754. The barbican was removed in 1826 to allow a circus access to the city and the east side arch was built in 1827. (Courtesy of Yorkshire Architectural and York Archaeological Society)

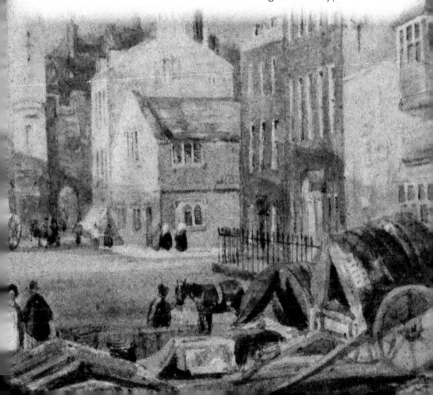

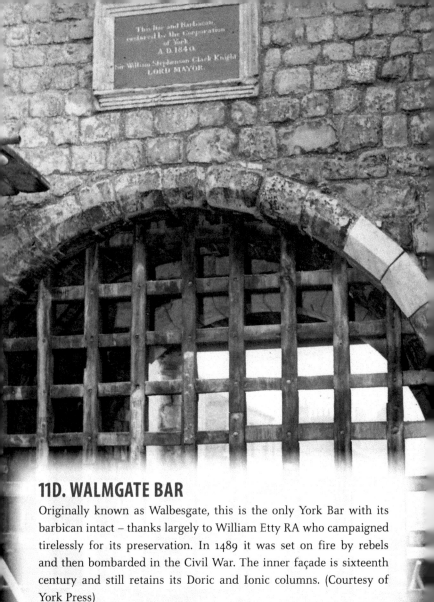

## 11D. WALMGATE BAR

Originally known as Walbesgate, this is the only York Bar with its barbican intact – thanks largely to William Etty RA who campaigned tirelessly for its preservation. In 1489 it was set on fire by rebels and then bombarded in the Civil War. The inner façade is sixteenth century and still retains its Doric and Ionic columns. (Courtesy of York Press)

## 11E. THE BAR CONVENT

St Thomas's Hospital can be seen on the right over the road and the Bar Convent is on the right on this side of the road. The Bar Convent is the oldest lived-in convent in England. It was established as a school for Catholic girls in 1686 by Frances Bedingfield, an early member of Mary Ward's Institute, in response to Sir Thomas Gascoigne's demand: 'We must have a school for our daughters.' Although still a working convent it is open to the public and is a wonderful museum.

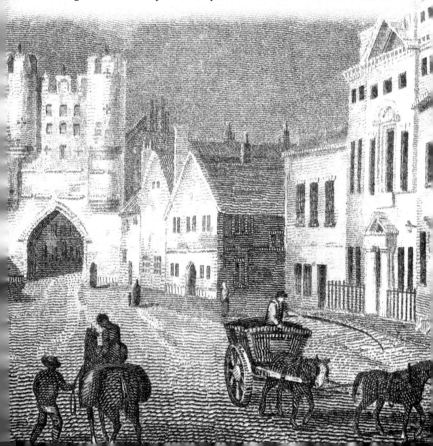

## 12. MARYGATE TOWER

Located on the corner of Bootham and Marygate, Marygate Tower was built around 1325. It was used to store monastery records after the dissolution in 1539. During the Civil War in 1644, however, the Earl of Manchester blew it up with a mine at the Battle of the Bowling Green. The documents that managed to survive the explosion were salvaged by Richard Dodsworth and are now in the Minster Library. The tower was rebuilt in 1952 and became the headquarters of the York Arts Society, housing a studio and library. (Courtesy of Yorkshire Architectural and York Archaeological Society)

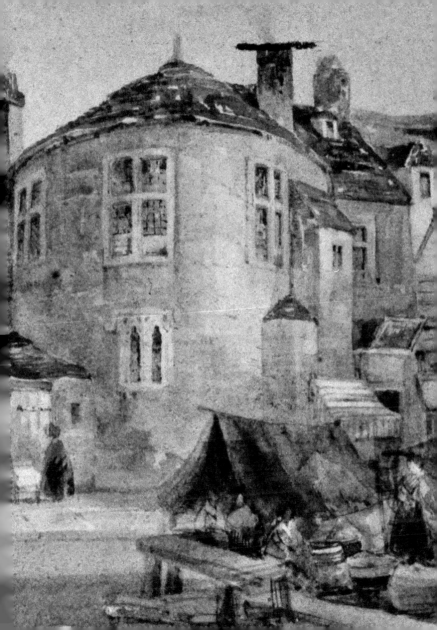

# 13. YORK MYSTERY PLAYS

The mystery plays were revived during the 1951 York Festival of the Arts, where they were performed on a fixed stage in the Museum Gardens – it was not until 1954 that a wagon play, *The Flood,* toured the streets. The 1951 production was the most popular Festival of Britain event in the country, with over 26,000 people seeing the plays. The word 'mystery' in this context means a 'trade' or 'craft' in medieval English; it is also, of course, a religious truth or rite. The medieval plays were traditionally sponsored by the city's craft guilds. Nowadays, the medieval Corpus Christi plays are produced every four years, most recently in 2016 by the York Guilds and Companies. Biblical tales from the Creation to the Last Judgement are paraded through the streets on pageant wagons as actors perform selections from the forty-eight high points of Christian history at twelve playing stations, with one guild taking responsibility for one episode. The sole surviving manuscript of the York plays is in the British Library and dates to around 1465. This photograph was taken during the interim production of 2014.

# 14. OUR LADY'S ROW

The Grade I-listed Lady Row cottages (Nos 60–72) date from 1316. They are the oldest surviving jettied cottages in Britain. Originally nine or ten houses for the priests at neighbouring Holy Trinity Church, the one at the southern end was demolished in 1766 to make way for a gateway to the church. They each comprised one room that was 10 by 15 feet on each floor. Rents collected went to pay for chantries to the Blessed Virgin Mary in nearby churches. Two pubs occupied the cottages at various times: the Hawk's Crest, from 1796–1819, and the Noah's Ark, around 1878.

# 15. MERCHANT ADVENTURERS

A merchant adventurer was a merchant who risked his own money in pursuit of his trade or craft. For centuries, up until 1835 when the Municipal Corporations Act transferred control to local councils, the guilds were all-powerful and controlled York's trade and industry. To do business in the city it was necessary to be elected a Freeman of the City – a man or a woman had to be a freeman before membership was allowed to the craft guilds. The Merchant Adventurers Guild goes back to 1357, when a number of prominent local men and women joined together to form a religious fraternity and build the Merchant Adventurers' Hall. By 1430 most members were merchants of one kind or another. They then set up a trading association or guild using the County Hall to conduct their business affairs and to meet socially, look after the poor in the almshouses in the Undercroft, and worship in the chapel. The York Dispensary, set up to look after York's sick poor (the County Hospital had no remit there), was originally in the Merchant Adventurers' Hall, moving to St Andrewgate and then to New Street in 1828. The next move was to the majestic, often overlooked, red-brick building in Duncombe Place in 1851.

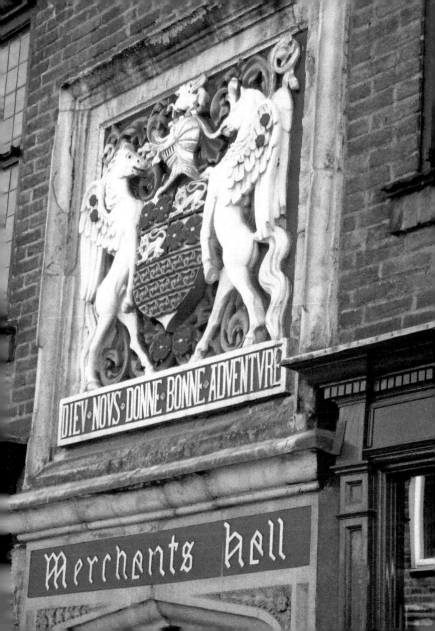

DIEV·NOVS·DONNE·BONNE·ADVENTVRE

Merchants hall

# 16. KING'S MANOR

This marvellous often overlooked building off Exhibition Square was originally built in 1270 as the house of the Abbott at St Mary's Abbey. It was rebuilt in 1480, with the new windows providing the earliest known examples of the use of terracotta as a building material. In 1561, after the dissolution, the Lord President of the Northern Council took possession of it. Visitors have included Henry VIII and James I, and during the Siege of York in 1644 it was the Royalists' headquarters. The ornate doorway with the stunning coat of arms at the main entrance is Jacobean – the 'IR' stands for James I, who ordered the manor be converted into a royal palace for him to stay in while travelling between London and Edinburgh. Charles I added the royal arms, which celebrate the Stuarts. After a long period of private lettings and decay, Mr Lumley's Boarding School for Ladies occupied it from 1712–1835 and then the William Wilberforce-inspired Yorkshire School for the Blind moved here in 1833. From the 1870s they gradually restored and enlarged the buildings, adding a gymnasium and a cloister to create a second courtyard. The school left in 1958 and the manor was then acquired by York City Council, who leased it to the University of York in 1963.

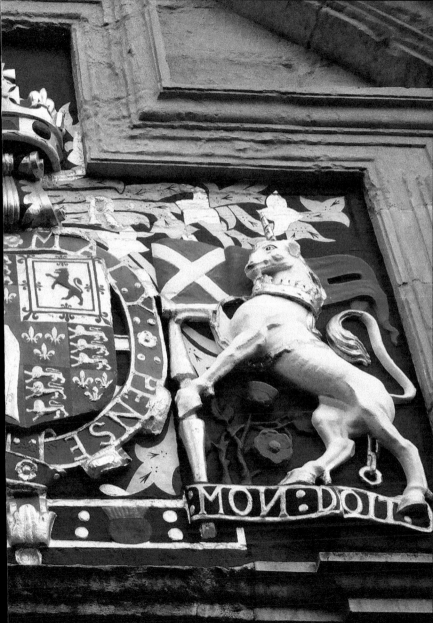

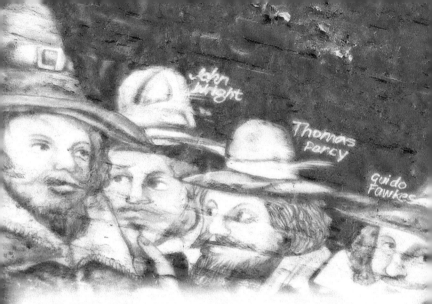

# 17. GUY FAWKES

Fawkes was born just off Low Petergate, baptised at St Michael le Belfry and was a pupil at St Peter's. As Captain Guido Fawkes he had a distinguished military record, and his expertise with explosives led the plotters to recruit him in their attempt to assassinate James I. Guy Fawkes, calling himself Johnson, a servant to Thomas Percy, smuggled thirty-six barrels of gunpowder under the House of Lords, ready for its royal opening on 5 November 1605. Just before midnight he was arrested, 'booted and spurred' and ready to make his getaway, having on his person a watch, lantern, tinderbox and slow fuses. He was interviewed by James I in his bedchamber, taken to the Tower to be tortured and finally 'hanged, drawn and quartered' as a traitor on 31 January 1606. Though he is still burnt in effigy each 5 November ('Plot Night', as it is called in parts of Yorkshire), no Guy is ever burnt at St Peter's. This photo shows the plotters' mural in the yard of the Guy Fawkes pub in Petergate.

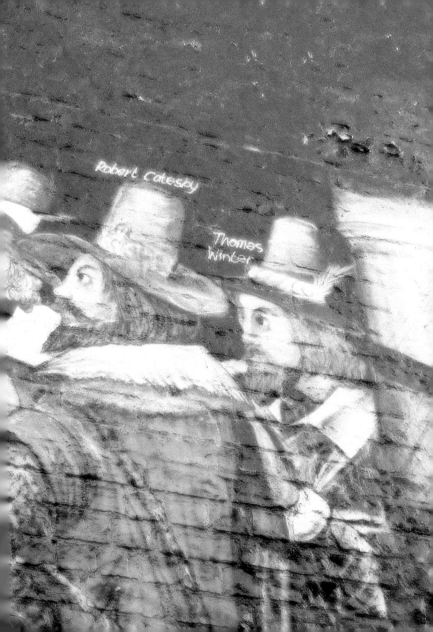

# 18. FLOODING

## 18A. SKELDERGATE

York, of course, is notorious for its near perennial flooding. The following pages illustrate this with photographs from the 1920s showing floodwater in and around the rivers Ouse and Foss. This one shows Skeldergate. (Courtesy of Yorkshire Architectural and York Archaeological Society)

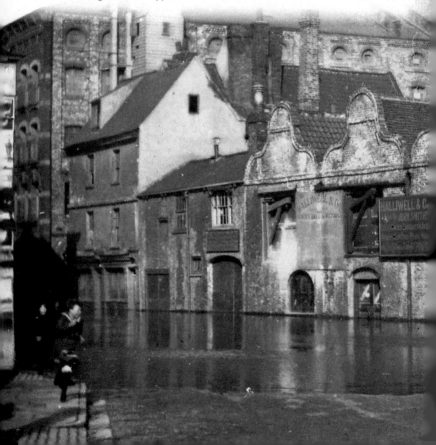

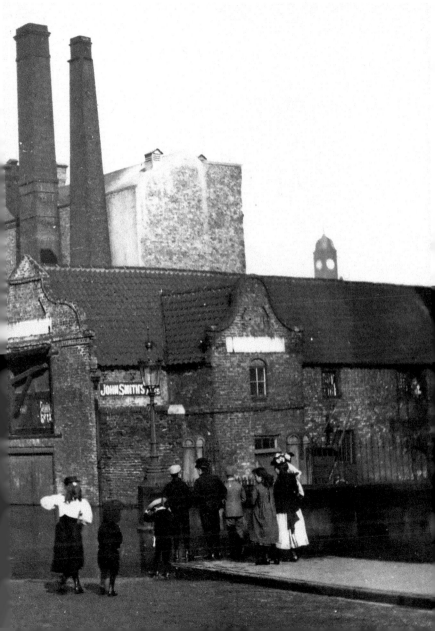

## 18B. OUSE BRIDGE

This image shows flooding during the 1920s, with onlookers peering down at it from the Ouse Bridge. (Courtesy of Yorkshire Architectural and York Archaeological Society)

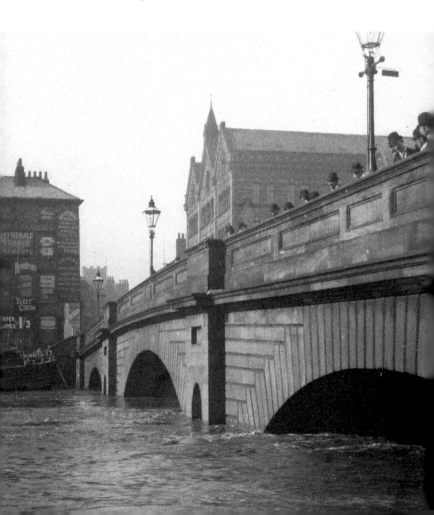

## 18C. CUMBERLAND STREET

A man paddles his boat in the floodwater along Cumberland Street in the 1920s. (Courtesy of Yorkshire Architectural and York Archaeological Society)

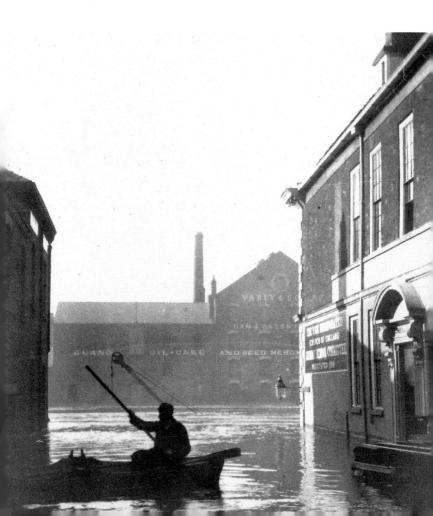

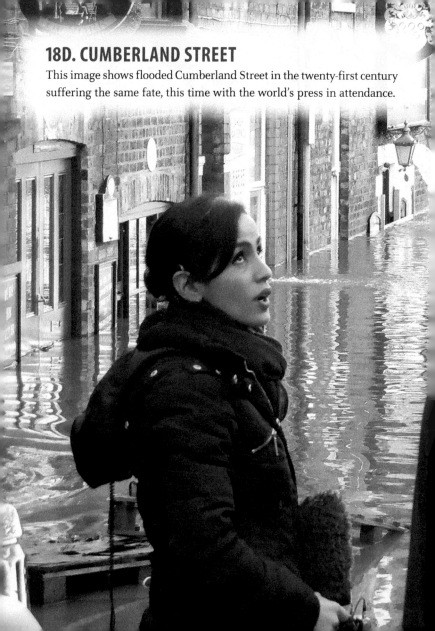

## 18D. CUMBERLAND STREET

This image shows flooded Cumberland Street in the twenty-first century suffering the same fate, this time with the world's press in attendance.

## 18E. CLIFTON GREEN

A carriage braves the floodwater at Clifton Green. (Courtesy of Yorkshire Architectural and York Archaeological Society)

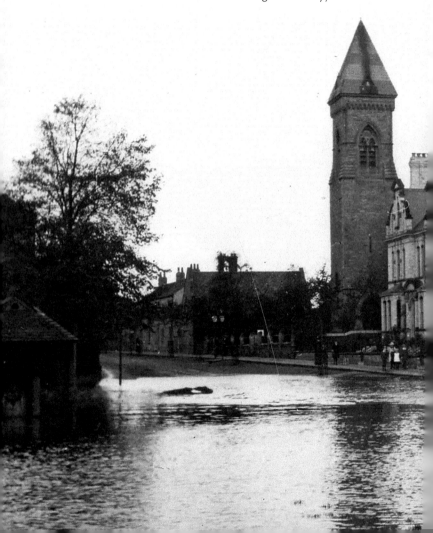

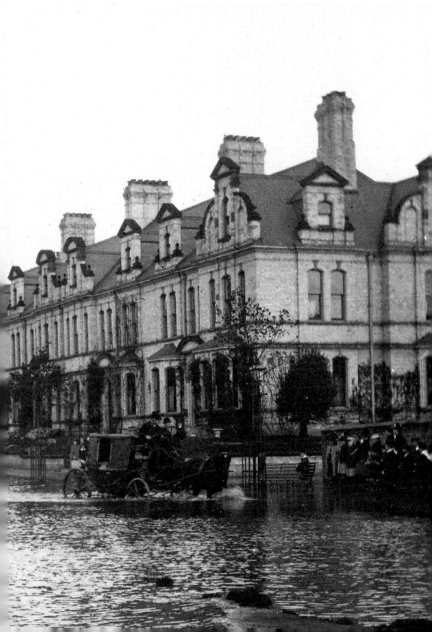

## 18F. CANAL BASIN

Canal Basin with the glassworks in the background. The first glassworks was opened in 1794 by Hampston & Prince near Fishergate, making flint glass and medicinal phials. The York Flint Glass Co. was set up in 1835 and by 1851 was a bigger employer than either Terry or Craven. In 1930 it was incorporated as National Glass Works (York) Ltd, which became Redfearn National Glass Co. in 1967. This was demolished in 1988 and was replaced by the Novotel. Sand for the works came via the Foss Islands Branch Line Depot, which was operational from 1879 to 1988 and also served the electricity power station and cattle market. (Courtesy of Yorkshire Architectural and York Archaeological Society)

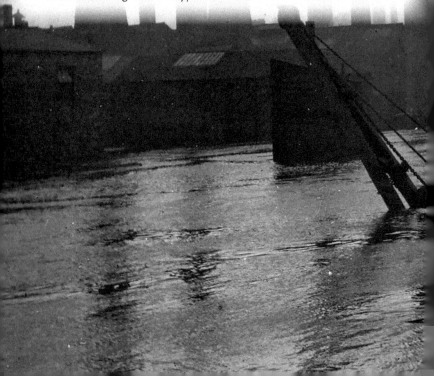

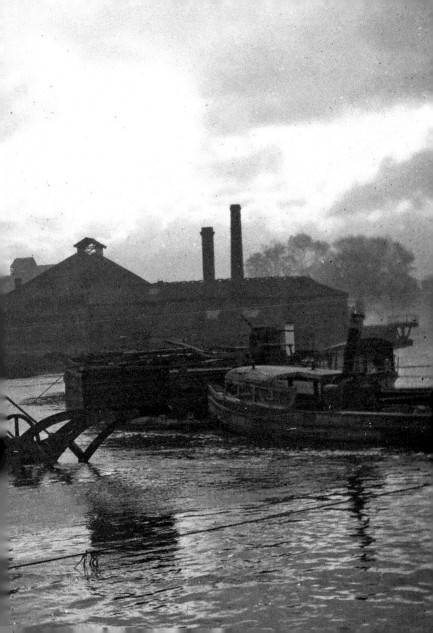

## 18G. ST GEORGE'S FIELD

This is where the York ducking stool was, which was used for scoundrels and women who sold short measures or bad beer and 'scolds and flyters'. The gallows nearby attracted large crowds, some coming by special train excursions as late as 1862. There were heated baths here from 1879 to 1972, which comprised separate men's and women's baths along with one for local residents without one at home. (Courtesy of Yorkshire Architectural and York Archaeological Society)

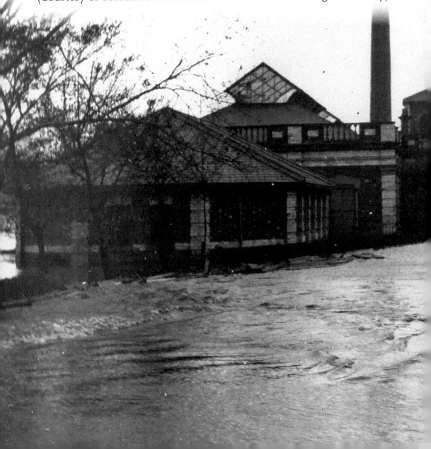

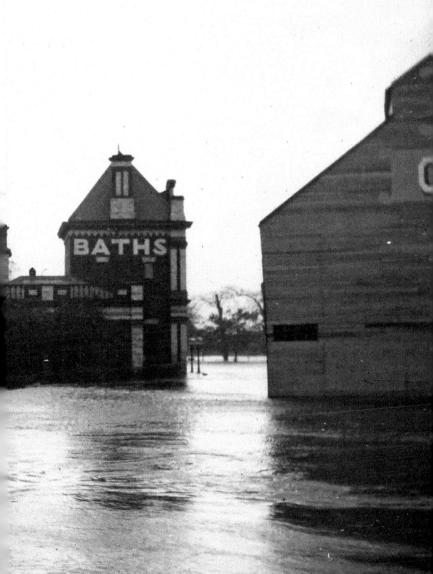

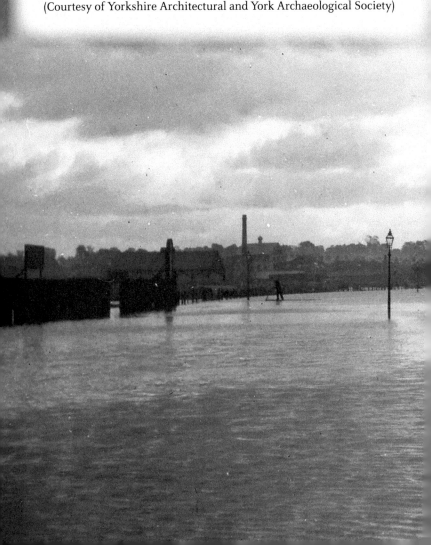

**18H. LIVING DANGEROUSLY IN FOSS ISLAND?**
Two people heading along a precarious pathway during 1920s flooding.
(Courtesy of Yorkshire Architectural and York Archaeological Society)

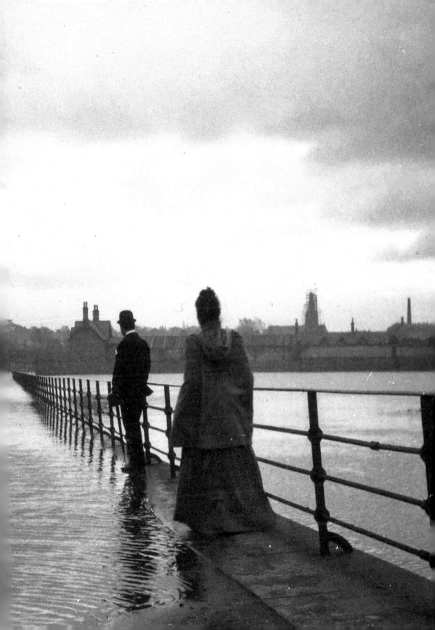

# 181. OUTSIDE THE PRISON WALLS

These were built in 1825 along Tower Street and demolished in the 1930s. They enclosed the Debtor's Prison and the Female Prison – both now occupied by the Castle Museum, which appropriately has a section devoted to prison life. Defoe, with the distinct advantage of seeing things from the outside, liked the prison, describing it as 'the most stately and complete of any in the whole kingdom, if not in Europe'. The cells in which prisoners like Dick Turpin spent their last days before execution can be visited (with impunity) – Turpin was hanged for horse stealing in 1739. (Courtesy of Yorkshire Architectural and York Archaeological Society)

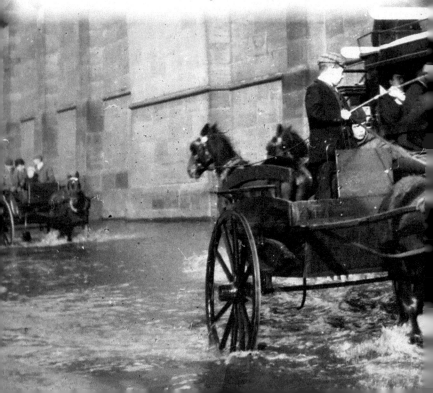

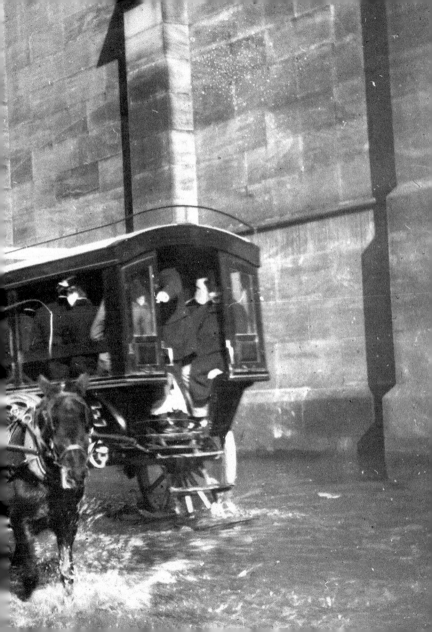

## 18J. MARYGATE AND THE BAY HORSE PUB

The Bay Horse was originally in the gatehouse to St Mary's Abbey (located opposite), but was obliged to vacate when the gatehouse was required for the keeper of the Yorkshire Philosophical Society's Museum in 1839. A new pub was built against the abbey walls, only to be demolished in 1893. In 1896 it was rebuilt over the road. (Courtesy of Yorkshire Architectural and York Archaeological Society)

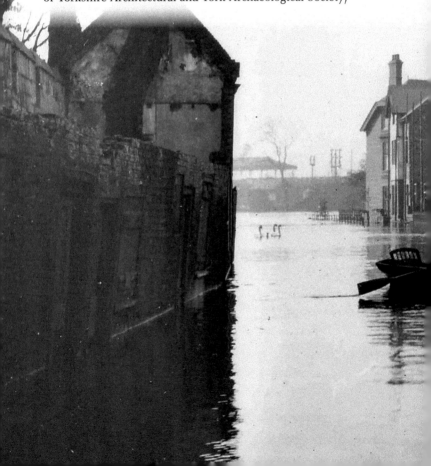

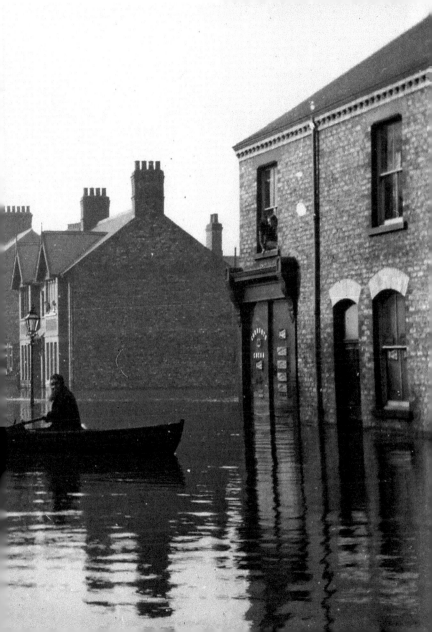

# 19. PUBS

## 19A. YORK TAP

The beautifully renovated York Tap at York station. 'Well worth missing your train for,' so says one of the online comments. It is a wonderful conversion from the old York Model Railway. Both rooms are exquisitely furnished and the ambience is excellent. The building, which was built in the early 1900s, features restored original fireplaces, stained-glass windows and skylights.

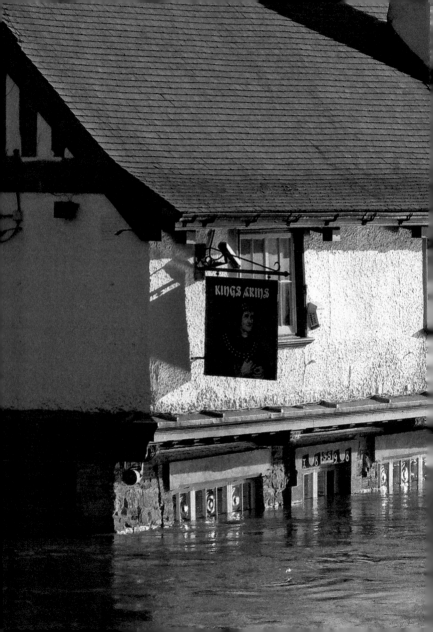

## 19B. KING'S ARMS

This is an early seventeenth-century building on King's Staith, traditionally a hotbed of crime and prostitution. Originally, the pub had no fireplaces or room partitions, so it may have been a custom house or a warehouse. Very thick walls protect it from floods, which recur to this day with alarming regularity. Due to the flooding, the cellars are on the first floor. Bodies of criminals were laid out here before being hung on and then flung from old Ouse Bridge just along the Staith.

It was first recorded as a pub in 1783 or 1795 as the King's Arms, then in the nineteenth century licensee George Duckitt renamed it Ouse Bridge Inn. It reverted to its old name in 1974. The inn sign depicts Richard III, who grew up at Middleham Castle. After becoming Duke of Gloucester he visited York frequently from his castle at Sheriff Hutton; he was very popular in York. The King's Arms is 'the pub that floods', and known as the pub that is never dry. On the right-hand side of the door is a board with the flood levels marked on it. In 2000 the water was 6 feet deep in the bar – deep enough to drown your sorrows in.

## 19C. YE OLDE STARRE INNE

Serving locals since at least 1644, this is York's oldest licensed public house. The striking gallows sign of the Olde Starre Inne still stretches across the street. It was originally erected in 1733 by landlord Thomas Bulmer, who was obliged to pay 5s in rent per year to the owner of the building over the street onto which it joined. In 1886 it read 'Boddy's Star Inn'. The pub is named after Charles I – popularly known as 'the Old Star' – and was used as a Civil War morgue, field station and operating theatre by the Parliamentarians, much to the disgust of the Royalist landlord. The cellar is tenth century and the well was once the only source of clean water in the area.

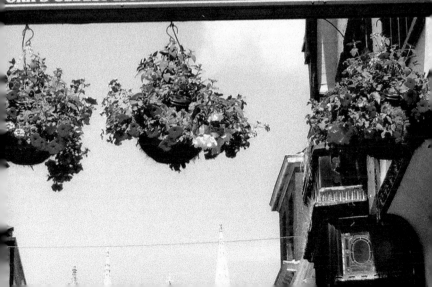

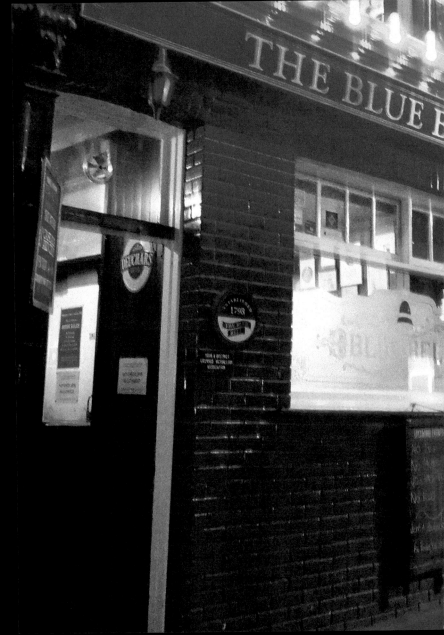

## 19D. THE BLUE BELL

This is York's smallest pub, and one of the best. It was opened in 1798 when the back of the pub faced on to Fossgate and the front was in Lady Peckett's Yard. In 1845 it was the meeting place of the Chartist Cooperative Land Society, an ill-conceived organisation that urged working-class people to become self-sufficient, spurning factory for field. The Quaker and largely teetotal Rowntrees were responsible for physically turning it around in 1903 – no doubt because one of their temperance-preaching adult schools happened to be in Lady Peckett's Yard, right behind the pub. With its unaltered 1903 interior, it is York's only Grade II*-listed Edwardian decor pub. The Blue Bell hosted fundraising meetings to raise the £2,000 needed to buy land for a ground at Fulfordgate (Eastwood Avenue) for the nascent York City, and later York City FC held their board meetings here. In the Second World War it served as a soup kitchen. Women were barred from the public bar until as recently as the 1990s. Drinking is encouraged in the narrow corridor, where a drop-down seat gives some rest to the weary.

# 20. STONEGATE

By common consent, Stonegate is one of the finest streets in England, if not Europe. It became York's first 'foot-street' when it was pedestrianised in 1971, paving the way for many more. You can still see the gallows sign of the Olde Starre Inne stretching across the street. Stonegate was once famous for its coffee shops (hence 'Coffee Yard'). The old Roman stone paving – hence the name – survives under the cobbles, complete with the central gulley for the chariots' skid wheels. It was the Roman *via praetoria*.

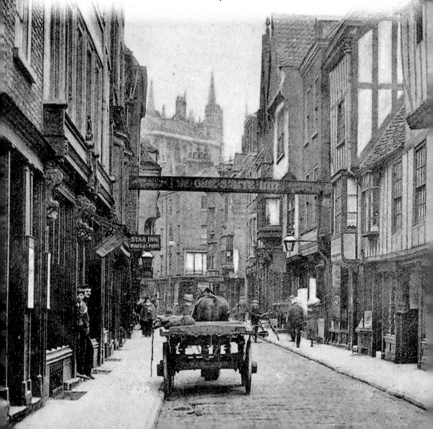

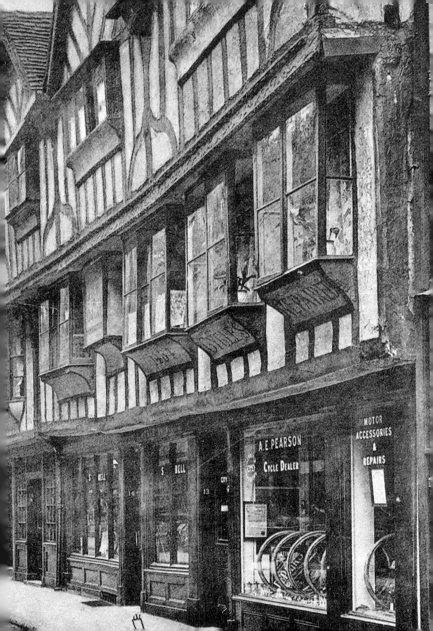

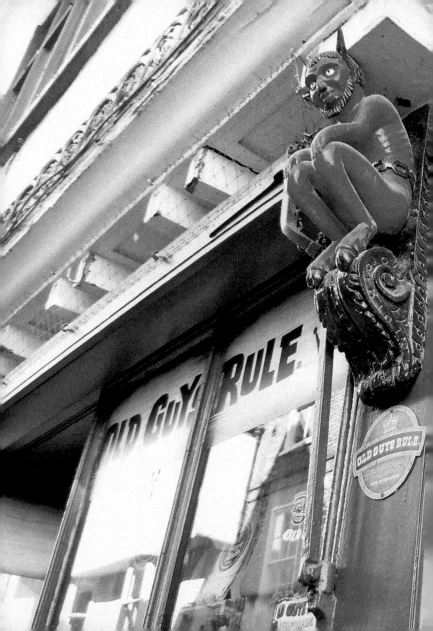

# 21. THE PRINTER'S DEVIL

The 'Printer's Devil' effigy at No. 33 Stonegate at the corner of Coffee Yard has been looking down on us since the 1880s and signifies the importance and prevalence of the printing, bookselling and publishing industries in the area. A 'printer's devil' was a printer's apprentice, a factotum. Printing was commonly known as 'the black art' on account of the inks. The Devil is indicative of the common practice of denoting one's trade with a symbol. Other examples can be found at No. 74a Petergate, with the wonderful cigar shop Native American Indian, complete with headdress from around 1800; and the Minerva, at the corner of Minster Gates, indicating a bookseller.

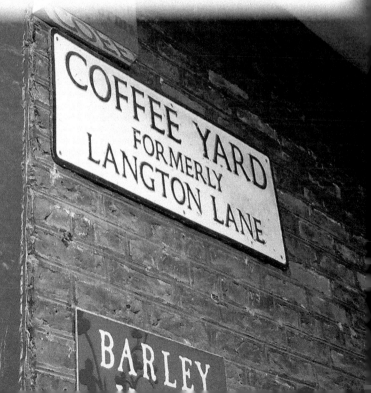

COFFEE YARD
FORMERLY
LANGTON LANE

BARLEY

## 22. ROWNTREES

In the early 1890s there was a Temperance Society coffee stand in Queen Street that was supported by the Rowntrees with a view to dissuading railway workers from mixing work with drink.

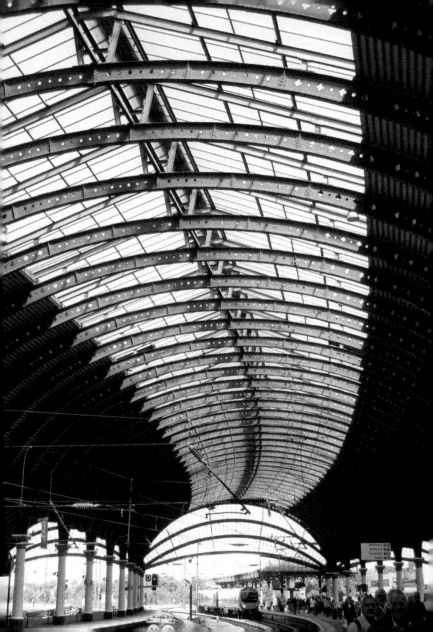

# 23. YORK STATION

York has had three railway stations. The first was a temporary wooden building on Queen Street outside the walls, which was opened in 1839 by the York & North Midland Railway. It was replaced in 1841 on Tanner Row by what is now called the 'old York' railway station, built by Robert Stephenson. As through trains between London and Newcastle needed to reverse out of George Hudson's old York station in order to continue their journey, a new station was built outside the walls. This is the present station, which was designed by the North Eastern Railway architects Thomas Prosser and William Peachey and opened in 1877. It had thirteen platforms and was at that time the largest station in the world. At 800 feet long and 234 feet wide, this is one of the most spectacular examples of railway architecture in the world, rightly and famously described as a 'splendid monument of extravagance', and 'York's propylaeum'.

# 24. YORK RACES

The Knavesmire, as it is popularly known, has long been a focus for entertainment – from public executions to horse racing today. Grazing horses and cattle were a common sight there from the early nineteenth century through to the 1960s, originally because local householders held grazing rights here and because grazing was the traditional way of managing the pasture. York Races moved to the Knavesmire in 1731 from flood-prone Clifton, sometimes attracting crowds of over 100,000. The races were accompanied by sideshows, gypsy bands, cockfights and executions at York's Tyburn. (Courtesy of *York Press*)

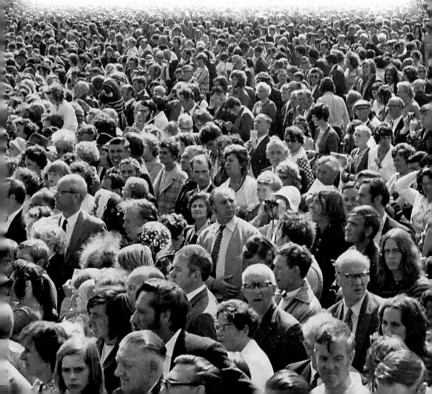

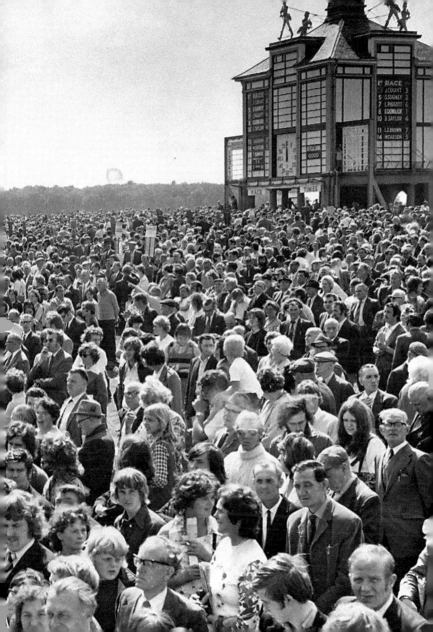

# 25. NATIONAL RAILWAY MUSEUM

One marvelous production that rolled out of York Carriage Works was the ambulance train made from existing carriage rolling stock. It comprised sixteen carriages and was known as 'Continental Ambulance Train Number 37'. It was 890 feet 8 inches long and weighed 465 tons when loaded – without a locomotive. Painted khaki, it bore the Geneva Red Cross painted on the window panels and frames on each of the carriages on both sides. It features as a wonderful exhibit in the museum.

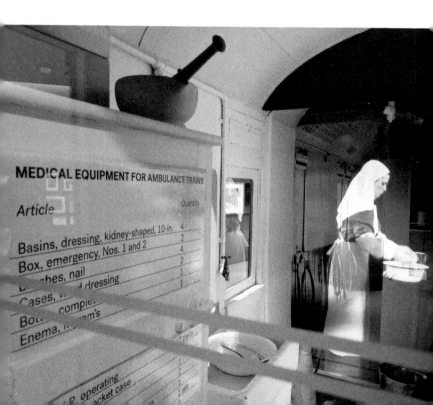

Overall, the Ambulance Car could carry between 445 and 659 patients and staff, depending on how it was configured. Obviously good ventilation, light and infection control were paramount. There were electric fans everywhere, with extra ones for gassed patients. To promote hygiene, round corners were used, and the toilets, washrooms and treatment room all had concrete floors. The kitchen was floored with lead while other areas were covered in linoleum. A smooth ride was essential for the injured, as such the train had bolster, side-bearing and auxiliary springs on the four-wheeled bogies, which ran on 'patent cushioned wheels'.

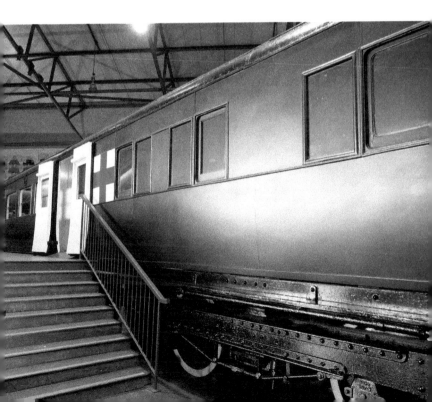

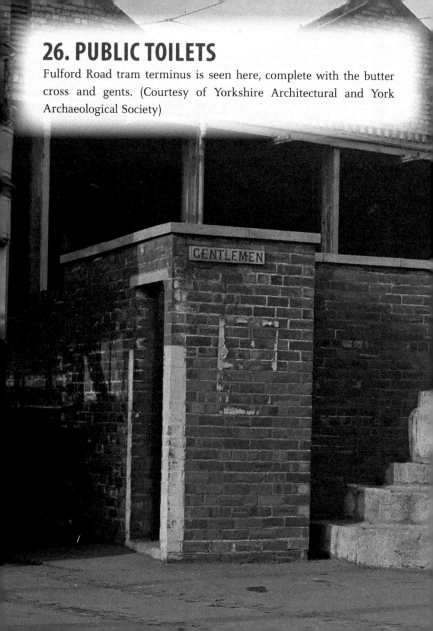

# 26. PUBLIC TOILETS

Fulford Road tram terminus is seen here, complete with the butter cross and gents. (Courtesy of Yorkshire Architectural and York Archaeological Society)

GENTLEMEN

## 27. BETTYS DIVE

On 1 February 1945 J. E. Mcdonald became the first of 600 airmen to scratch their names on the mirror at Bettys during the Second World War. Also known as Bettys Bar, it was a regular haunt of the hundreds of airmen stationed in and around York, who included many Canadians from No. 6 Bomber Group. One signatory, Jim Rogers, borrowed a waitress's diamond ring to scratch his name on the mirror. The mirror is still on display downstairs in Bettys and many have returned to reflect on their efforts. Sadly, however, many of the signatories did not survive the war. (Courtesy of *York Press*)

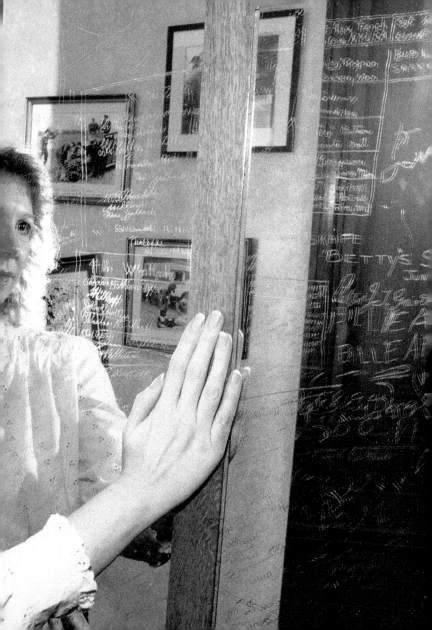

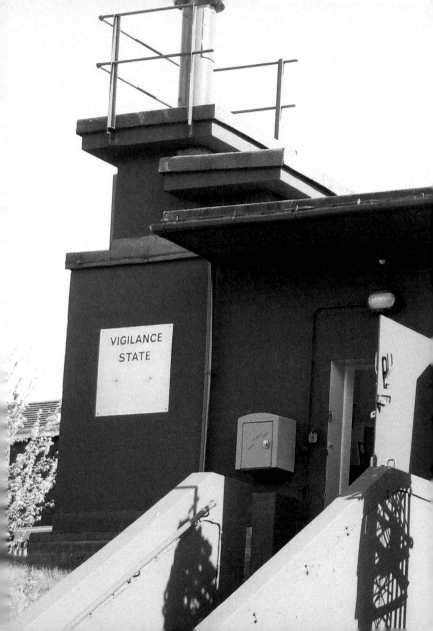

# 28. YORK'S NUCLEAR BUNKER

This was York's worst kept secret. Opening – or rather closing – in 1961, this piece of Cold War furniture was officially No. 20 Group Royal Observer HQ and operated by UKWMO, the UK Warning and Monitoring Organisation. Its role was to function as one of twenty-nine monitoring and listening posts in the event of a nuclear explosion. Decommissioned in 1991, English Heritage have opened it to the public to enable them to see the decontamination areas, living quarters, and communication centre and operations rooms.

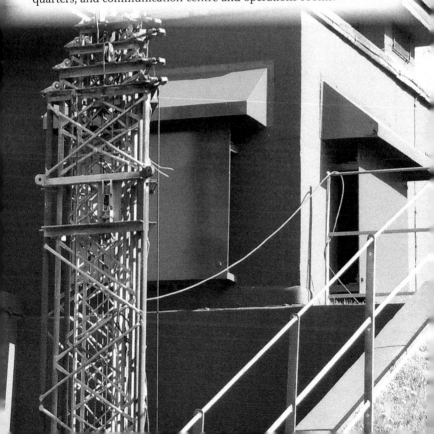

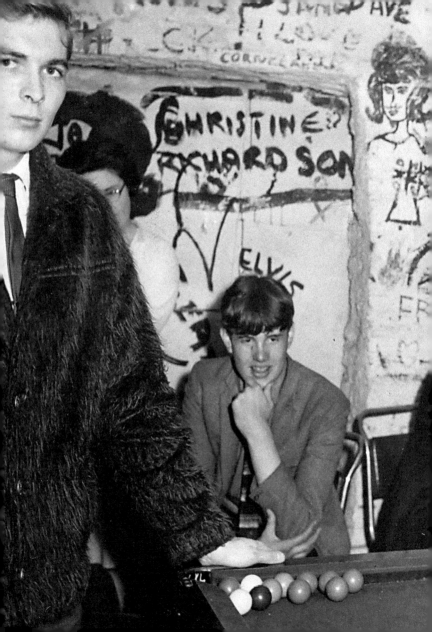

# 29. KAVERN CLUB

Sounds of the 1960s in Micklegate. York in the 1960s had its own home-grown music scene, with venues like the Kavern Club, the Mandrake in Stonegate and Neil Guppy's Enterprise Club hosting live music by young city bands. Some of it started in the 1950s, but much of it persisted throughout the '60s or originated in that decade. The Kavern Club started life as a coffee bar and was in the basement of the Labour Party headquarters, appropriately decorated with graffiti. By 1964 there were 100 or so local groups performing in the city. The crime rate allegedly fell because most young people were either performing in groups or watching them. (Courtesy of *York Press*)

# 30. THE AFGHANISTAN WINDOW

In July 2015 a very special event took place in All Saints, Pavement: the unveiling of the Afghanistan 2001–2014 window, in which three fallen soldiers from York are commemorated along with the many other York citizens who served there. One of the country's premier stained-glass artists, Helen Whittaker of Barley Studios in Dunnington, installed the window. It was funded by the City of York Afghanistan Commemorative Appeal, which was launched by The Press in 2011 and has raised more than £17,000 'to recognise the city's sons and daughters who answered the call of duty in Afghanistan, and provide a memorial to the three York servicemen who made the ultimate sacrifice: Marine David Hart, Trooper Ashley David Smith and Lance Bombardier Matthew Hatton. Helen said the main focus of the window design wasthe traditional symbol of peace in the form of a dove, which was also the symbol of the Holy Spirit ... Regiments which had lost men serving in Afghanistan: the Royal Dragoon Guards (maroon, gold and green), the 40th Regiment Royal Artillery (red and blue) and the Royal Marines (blue, red, green and yellow). Helen added "The three York servicemen are represented as individual sets, proudly displaying their regimental badges, and flying upwards towards the heavenly City, a golden circular light beneath the dove, that illuminates the path of those no longer with us. The yellow colour also reminds us of the sun and desert earth of Afghanistan".'